LOS RESTOS DE LA REVOLUCIÓN

KEVIN KUNISHI

Daylight

Editors: Taj Forer and Michael Itkoff
Design: Ursula Damm
Copyediting: Sally Robertson

ISBN 978-0-9832316-2-2

Printed in China

Daylight Community Arts Foundation
Fax +1-775-908-5587
E-mail: info@daylightmagazine.org
Web: www.daylightmag.org

PREFACE

The mists gather slowly in the highlands of Jinotega.

These hills had been a place of refuge, a legendary land of spirits where the devil himself was rumored to reside.

I had been warned: the landscape of the past, with all of its blood and torn flesh, would fade into that pallid haze.

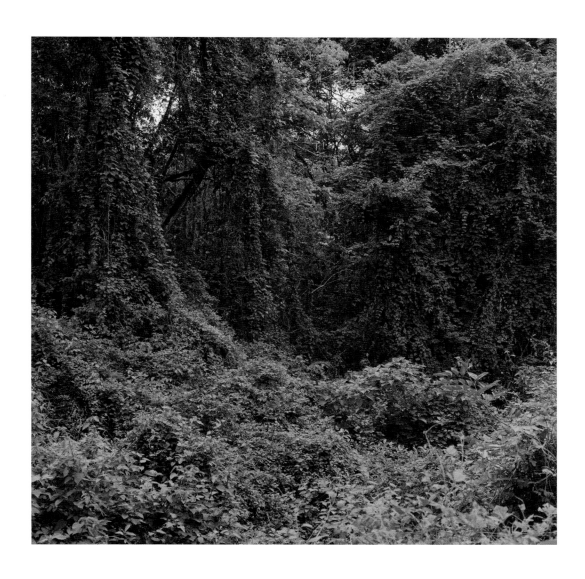

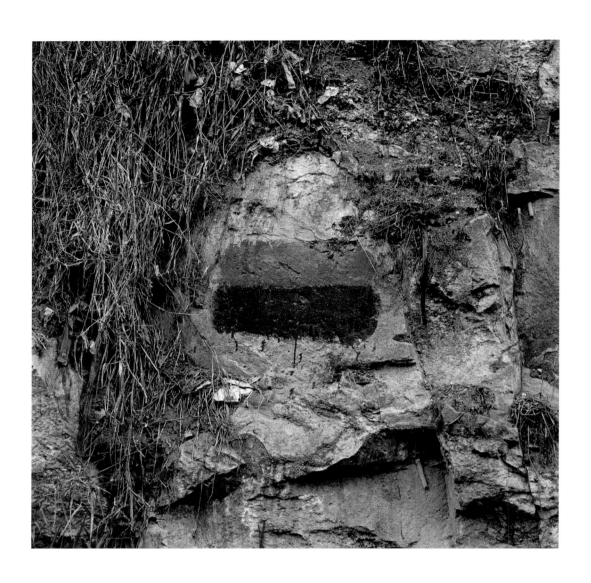

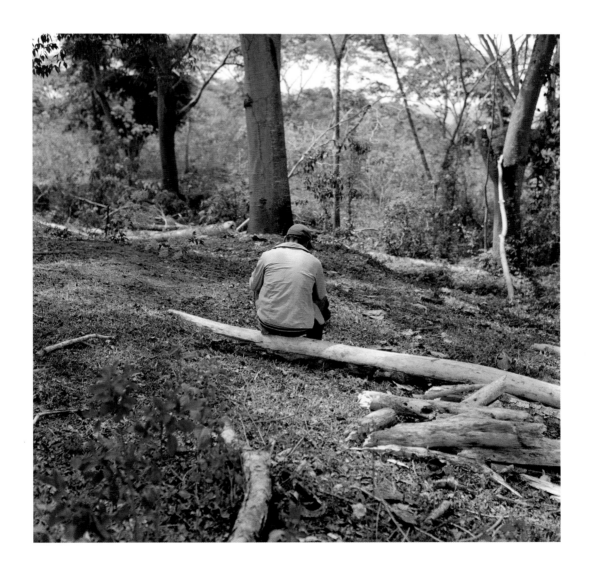

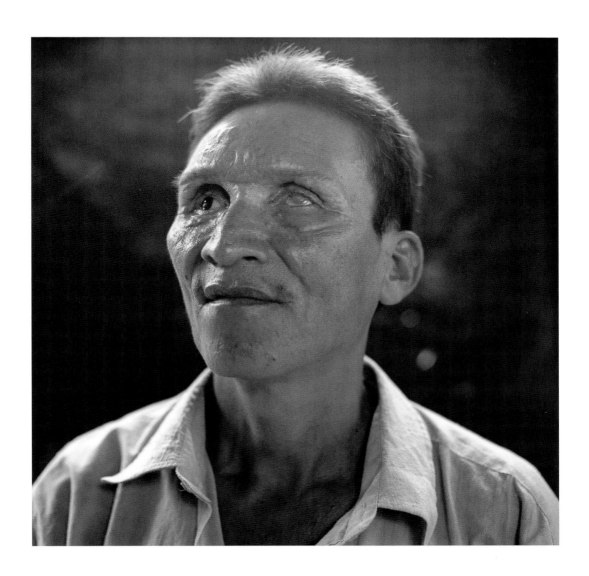

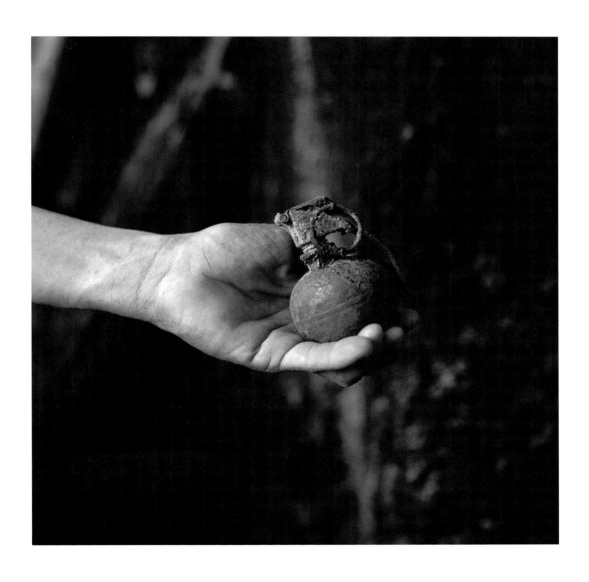

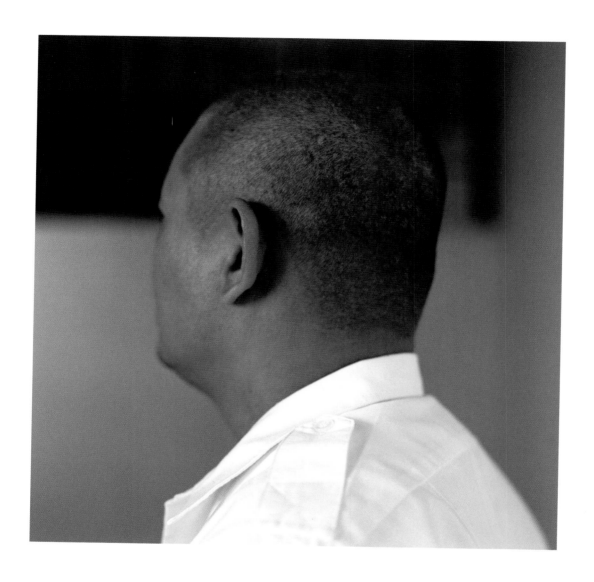

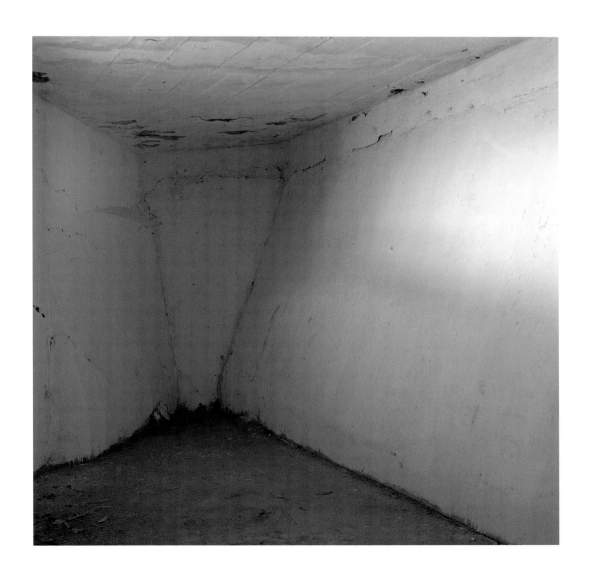

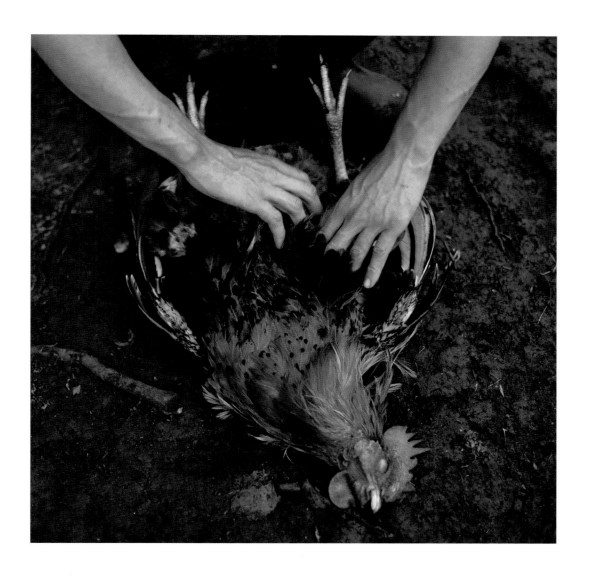

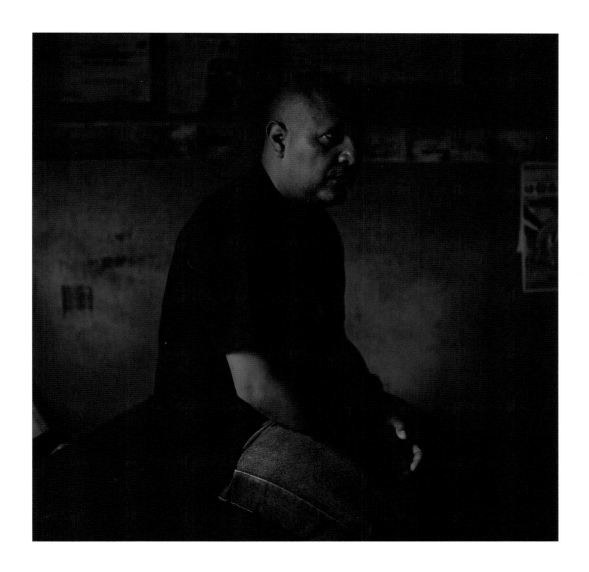

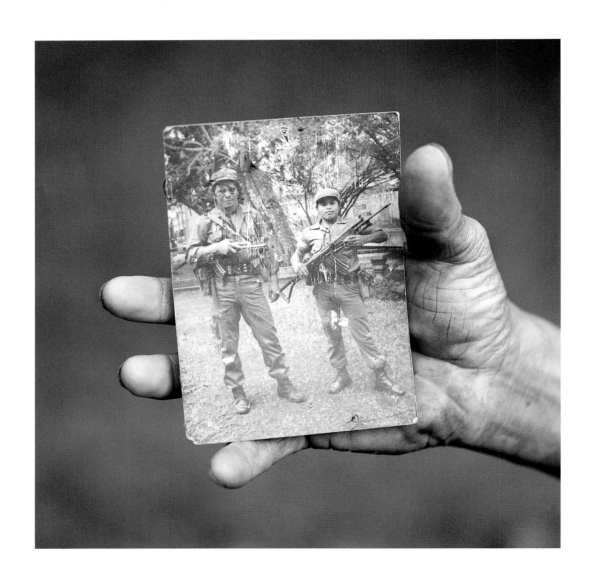

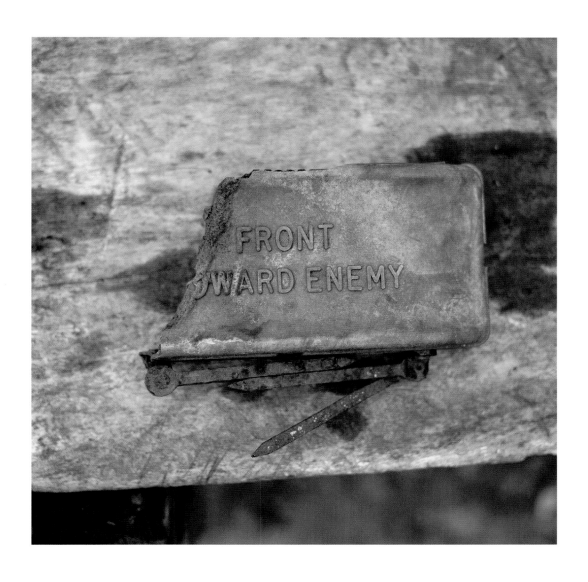

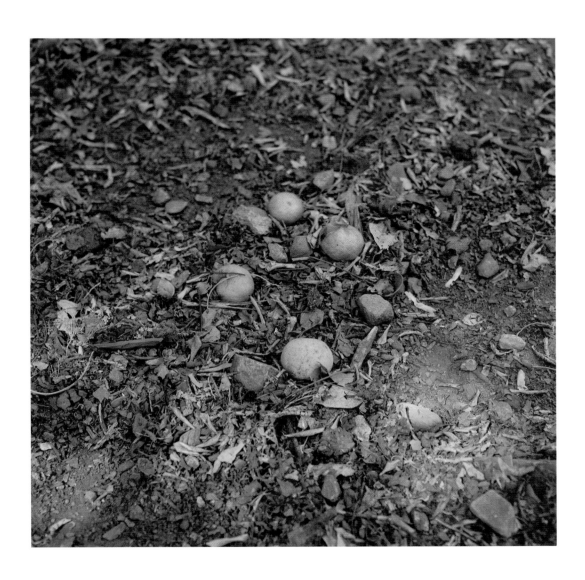

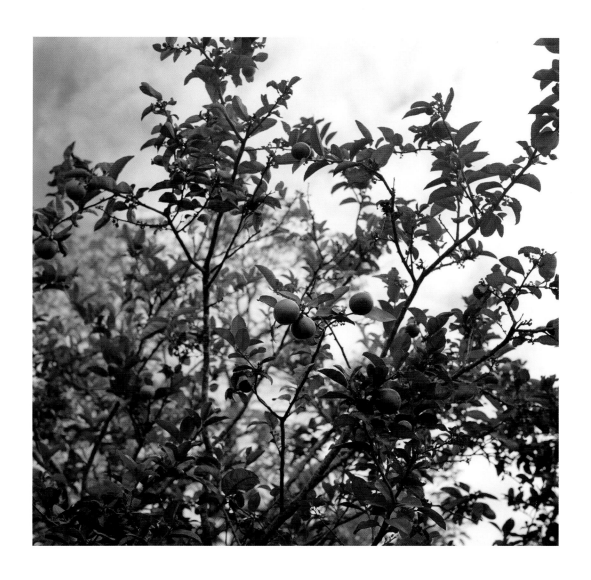

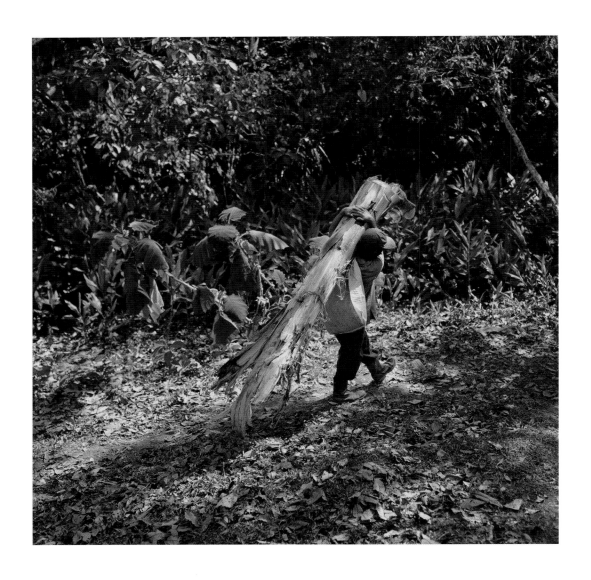

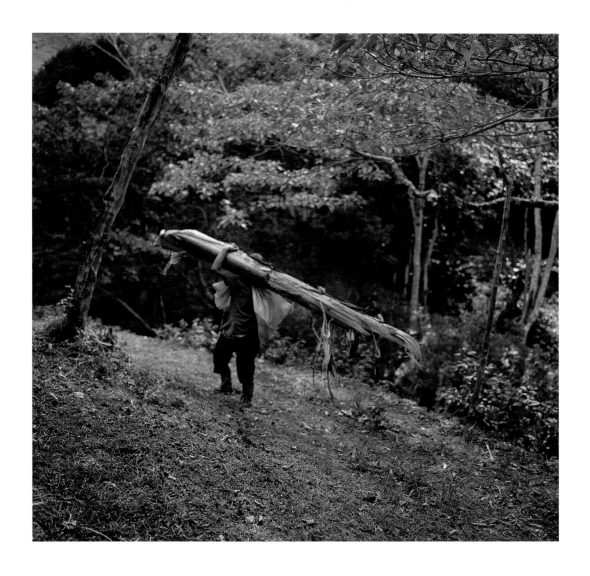

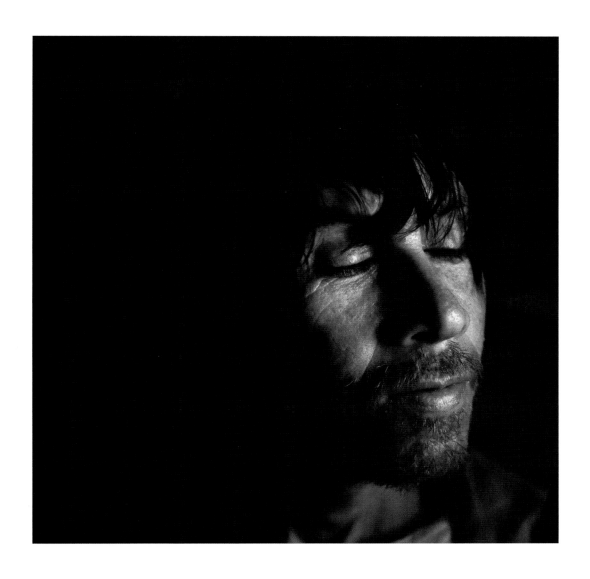

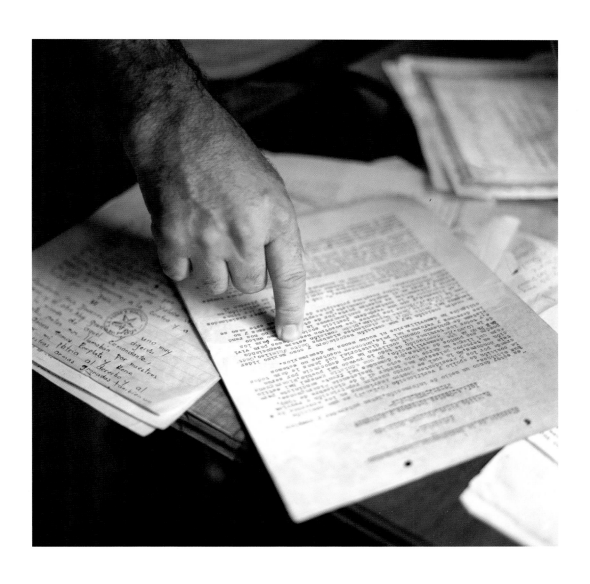

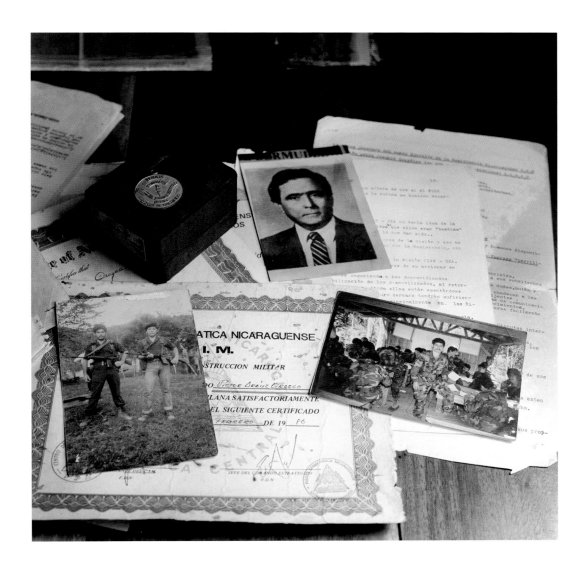

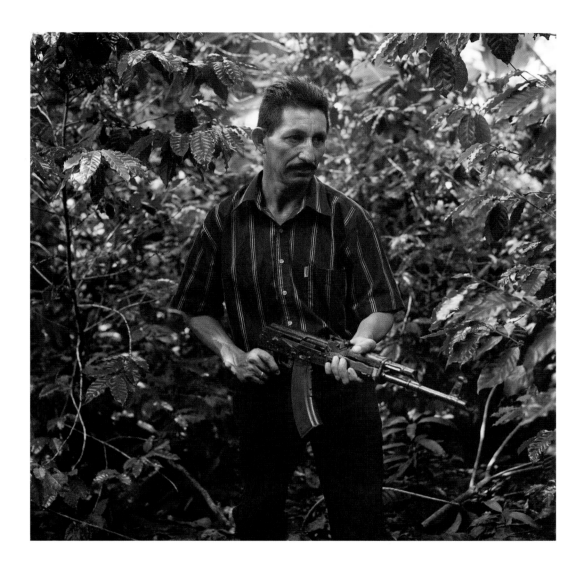

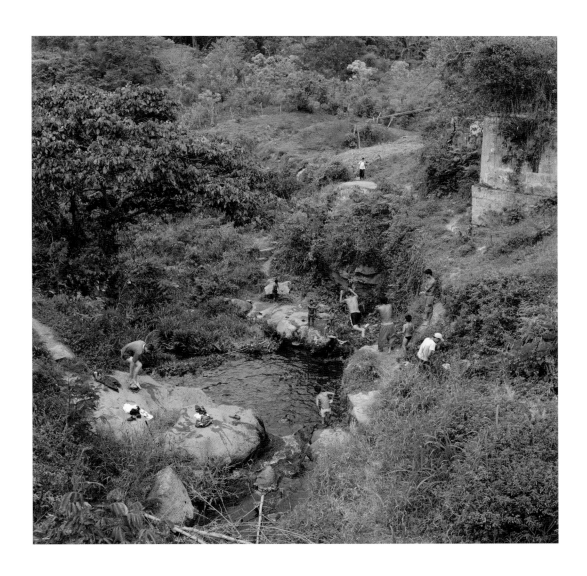

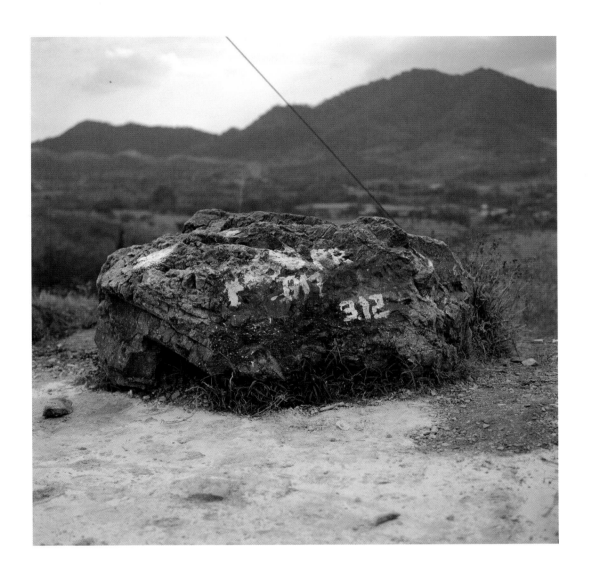

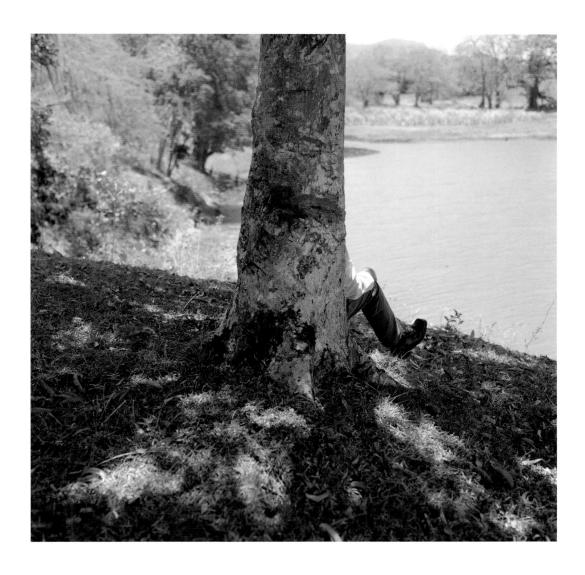

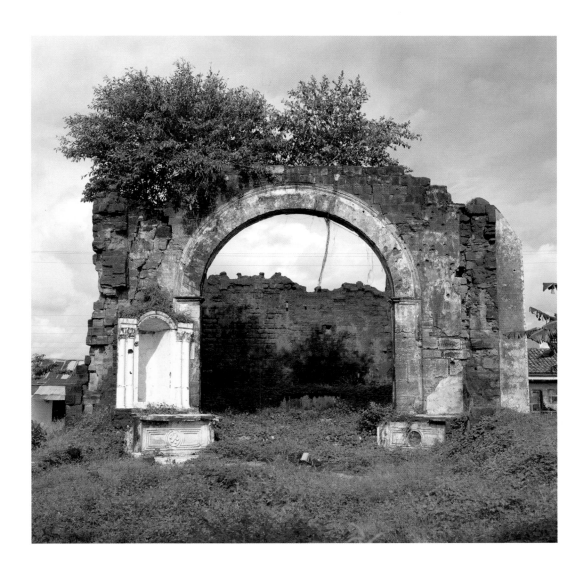

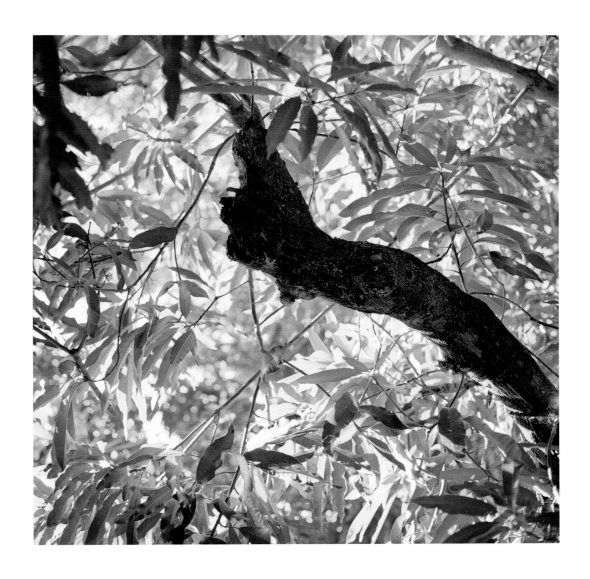

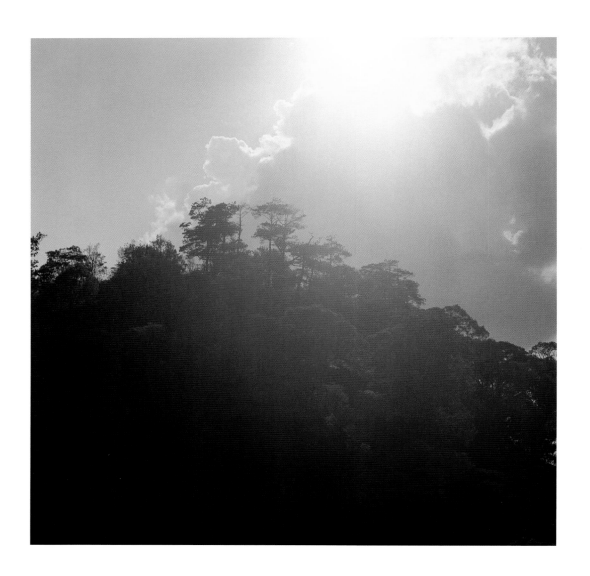

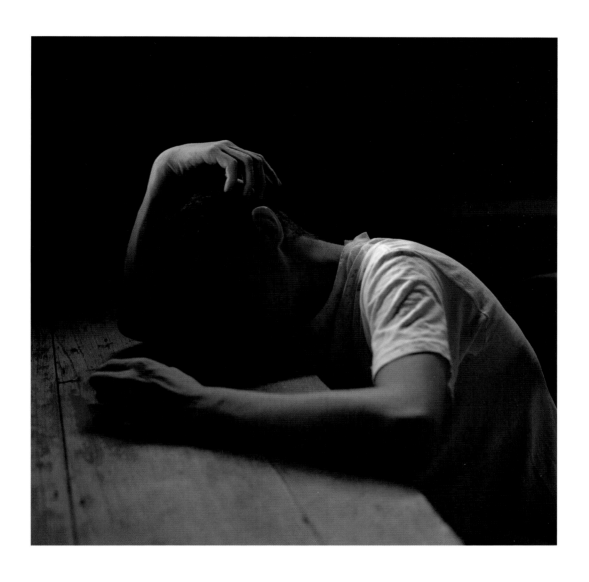

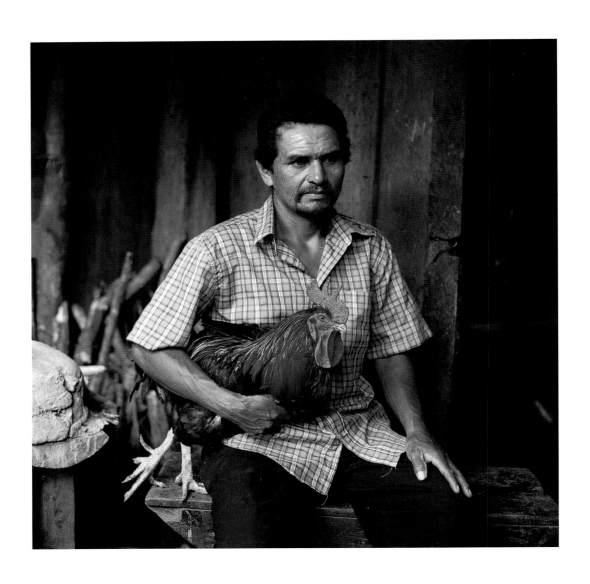

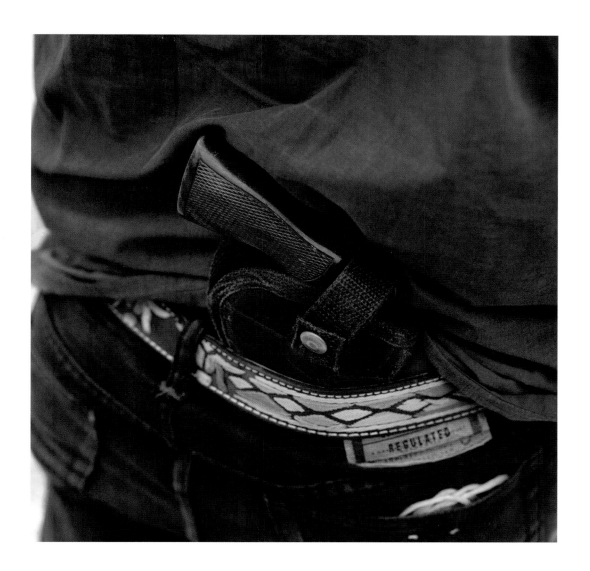

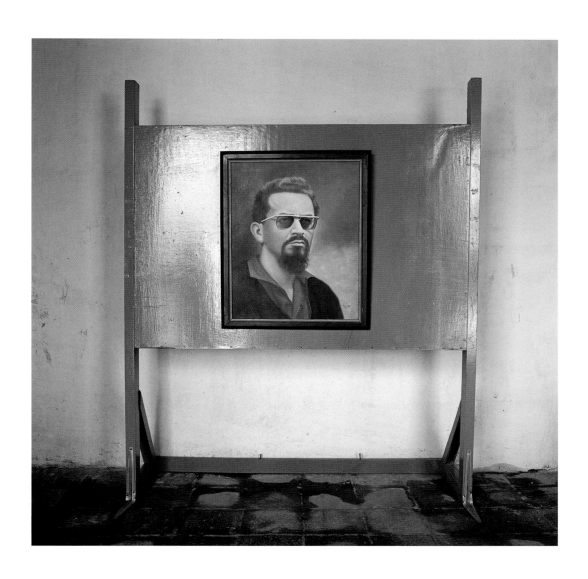

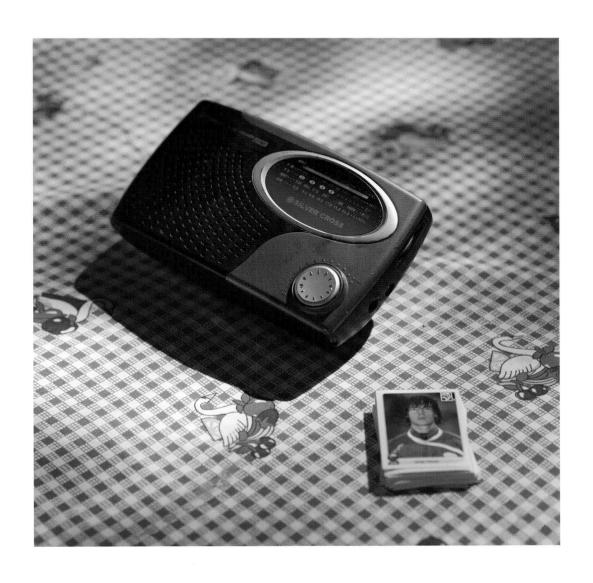

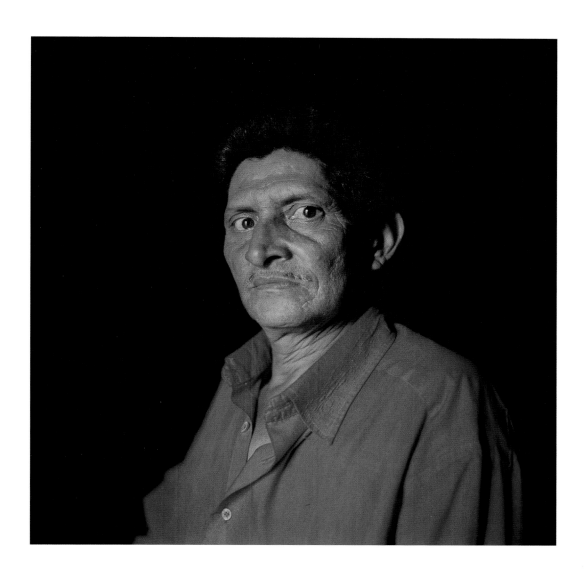

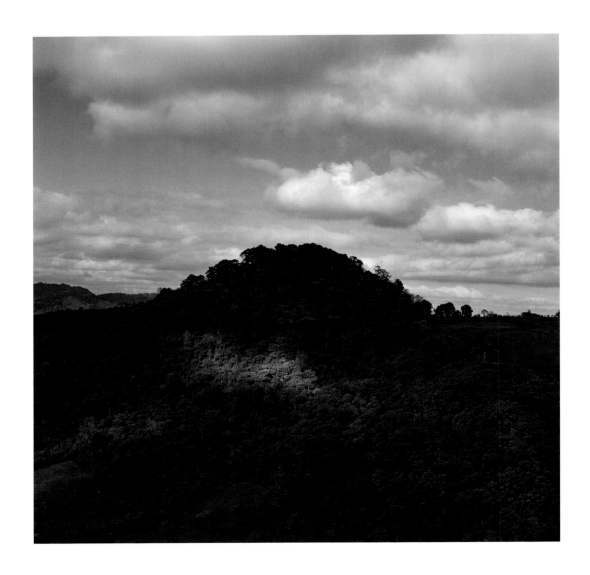

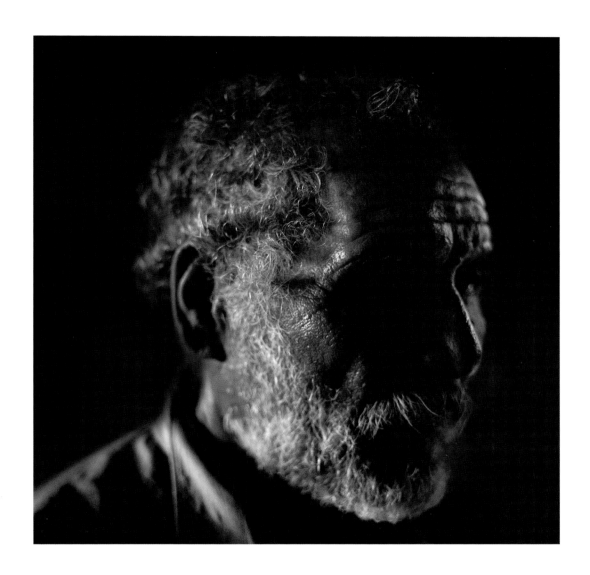

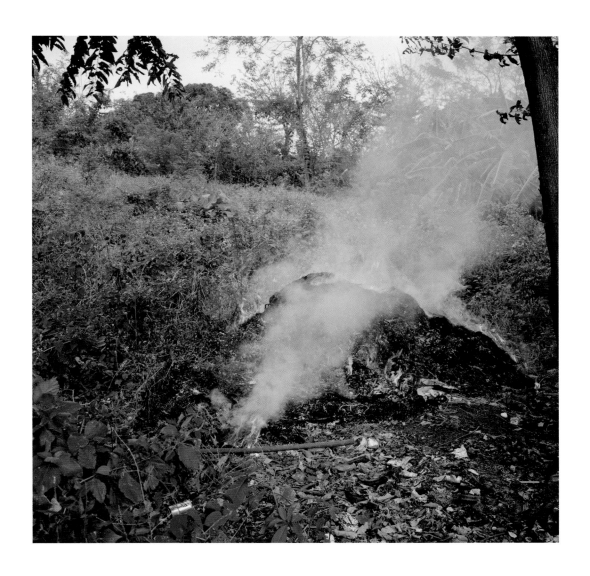

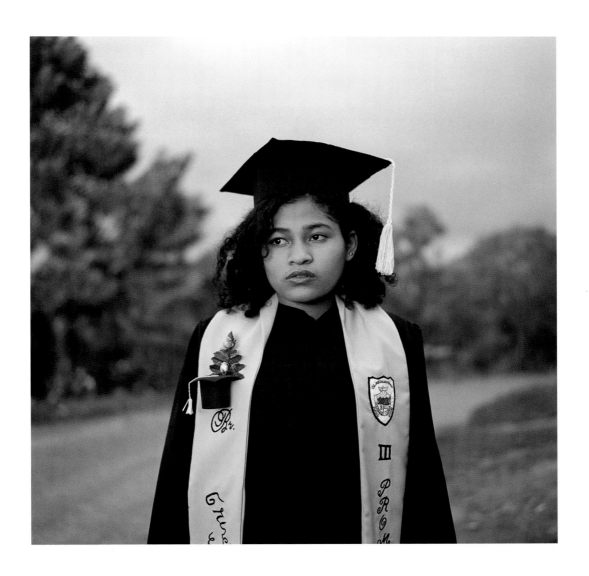

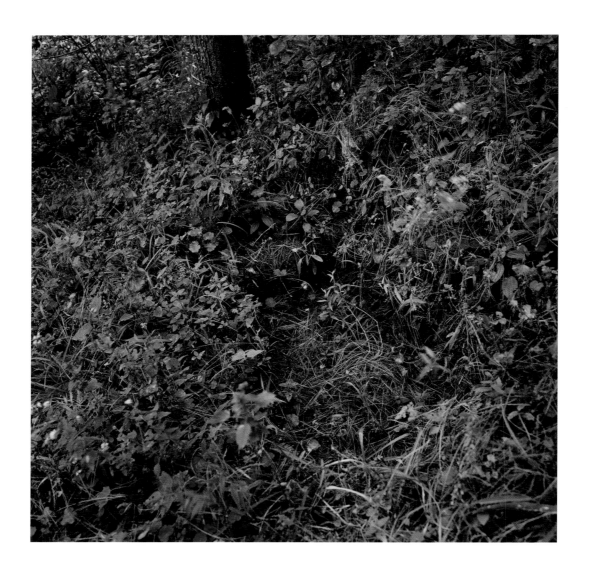

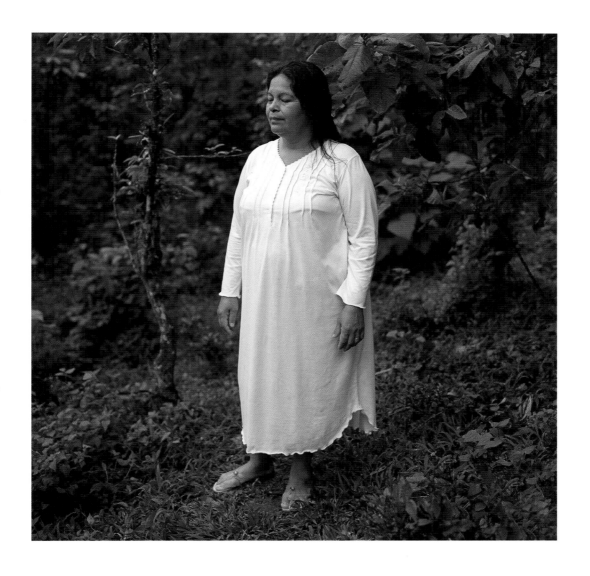

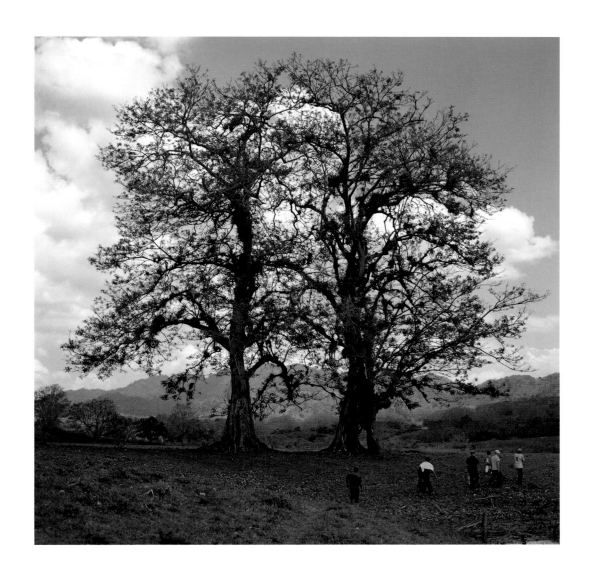

AFTERWORD

In 1979, after over a decade of struggle, the socialist Sandinista movement in Nicaragua overthrew the dictator, Anastasio Somoza Debayle, and ended the family's more than forty-year reign. The Sandinista National Liberation Front, or FSLN, quickly began the work of applying its social and ideological values in the hopes of creating a better Nicaragua.

Unfortunately, the United States government had other plans. In the Cold War environment of the 1980s, the prospect of a socialist government gaining a foothold in Central America was deemed unacceptable. The CIA began financing, arming, and training a clandestine rebel insurgency to destabilize the government. These anti-Sandinista counter-revolutionaries became known as Contras. Between 1980 and 1990, Nicaragua was the battleground of conflicting political ideologies. The promise of a bright future was lost as the nation descended into civil war.

Twenty years later, between 2009 and 2010, I traveled throughout Northern Nicaragua to consider the legacy left behind.

The photographs within this book are notational records of that experience; they are an attempt to move beyond broad ideology and rhetoric, and navigate the collective memory of those involved. Although at one time sharply divided by two polarized political philosophies, the survivors are now bound by a landscape filled with physical and psychological scars. The markers of affiliation are slowly fading, but the horrors of war remain.

PLATE INDEX

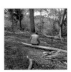

3. Sandinista MI-24 Helicopter Crash Site, Between Pantasma and Quilalí, 2010

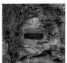

4. FSLN #016, North Road Out of Jinotega, 2010
 Red and black Sandinista graffiti painted on a rock wall. The black signifies
 death and the red refers to a rebirth or resurrection.

5. Sharpening the Machete, Pantasma, 2010

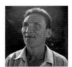

7. Pedrito, Quilalí, 2010 (Contra)
 *"The first grenade hit and killed the guy in front of me. You could see his
 intestines. On the way out another grenade hit, blew me back, and cost me my
 sight. The dirt and smoke landed all around me."*

 We stopped in a small village on our return from Quilalí. That is where I met Pedrito.
 He described the explosion of the grenade, the ringing in his ears and the scream-
 ing all around him. He explained why he had taken up arms, how he had said
 goodbye to his family and crossed the Rio Coco to train in Honduras. Like most
 Contras, he took a code name to protect his loved ones at home.

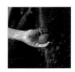

9. Raul's Grenade, Wiwilí, 2010
 U.S.-issued M67 fragmentation grenade unearthed after twenty years.

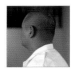

10. Julio, León, 2009 (FSLN)
 *"I was fourteen. They grabbed me on my way home from playing baseball. My
 clothes were covered in dirt. They accused me of returning from training with the
 Sandinistas in the mountains. I was thrown in a cell with forty others for three
 months. That is where I learned to fight."*

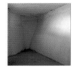

11. Julio's Cell at El Fortín, León, 2009
 Forty suspected political dissidents were crammed into this small cell during
 the Somoza regime. The cell was so overcrowded, prisoners would take turns
 climbing the angled walls until their legs gave out so that others could attempt
 to stand normally.

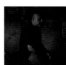

13. Untitled, Jinotega, 2010

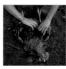

15. Juan, Jinotega, 2010 (FSLN)

"We drank from the river...walked about fifty yards. It was there we found twenty dead bodies in the water. My friend started vomiting. It didn't matter to me, I never got sick.

In the jungle all you see are shades of brown, green, and the deep blue sky. After the war I remember feeling blinded by all the different colors. Reds, purples, oranges. In the jungle you never walk on trails, you scurry under the brush. It took some time getting used to walking upright again."

Juan had been a state security agent seeking out suspected Contra collaborators.

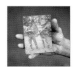

16. José, La Fundadora, 2010 (FSLN)

José Morales, holding a photograph of himself training in Cuba at the age of eleven. Recruits as young as ten years old were filling the ranks of the FSLN as fighting with the Contras intensified. After the fall of Somoza, Cuba began intensely providing the Sandinista government with military "advising," education, health services, and economic support.

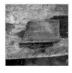

17. Claymore Mine, Quilalí, 2010

Detonated U.S.-issued M18A1 claymore mine found by two kids while chasing an iguana on the outskirts of Pantasma.

19. Rotting Oranges Outside Pedrito's House, Quilalí, 2010

21. Orange Tree, La Fundadora, 2010

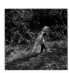

22. Charillo #003, Jinotega, 2010 (FSLN)

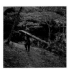

23. Charillo #026, Jinotega, 2010 (FSLN)

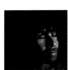

25. Charillo #003, Jinotega, 2010 (FSLN)

Charillo emerged from the brush, torn clothes and covered in dirt.

He looked me over and asked *"American?"*

"Yes," I answered *"How did you know?"*

"When I would kill Contras they wore boots like yours." He smiled and quickly wandered into the shoulder-high coffee plants that surrounded us.

He kept his distance, rarely coming into the house for dinner. He preferred to sit outside and watch me eat.

Later, I came to learn that he fought for four years in the jungle and was the lone survivor of his unit. After the war, homeless and destitute, he was found wandering the streets of Matagalpa. A fellow veteran named Antonio took him in to live with his family and work the farm.

Charillo sleeps on a wooden bed in the storage shed, surrounded by barrels of fertilizer and pesticide. We shared the same wall at night. I could hear him whispering to his newborn kittens and to people who now lived only in his imagination.

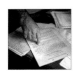

27. CIA Interrogation Mandates, Pantasma, 2010

A former Contra commander points to CIA-issued documents.

"Exposed atrocities committed by the Contras created significant political backlash in the U.S. As a result, the CIA issued specific guidelines regarding human rights directives and interrogation procedures to Contra commanders."

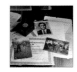

29. Keepsakes, Pantasma, 2010

Personal photographs, commendations, and training certificates of a former Contra commander.

The back middle photograph is of Enrique Bermúdez, aka "Commandante 380," commander of the primary Contra military group known as the Nicaraguan Democratic Force (FDN).

Bermúdez was assassinated in a Managuan hotel parking lot shortly after the war in 1991.

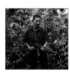

31. Raul with AK-47, Wiwilí, 2010 (Contra)

"The Sandinistas would gather up families and burn their houses down. Those who did not leave the mountainside were considered Contra so they would kill them by burning them with gas. We saw what they did."

Fearing revenge killings or possibly a return to fighting, many Contras did not turn in their weapons, choosing instead to bury them in the jungle.

Raul's son kept a lookout as we dug it up. It was buried near a tree in a burlap sack with a couple old rusted grenades. A rag was doused with gasoline to lubricate and clean the weapon, and within twenty minutes it was ready. Simple and reliable, the Kalashnikov held up well over the years.

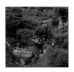

33. Swimming Hole, La Fundadora, 2010

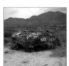

35. FSLN #027, South Road out of Jinotega, 2010

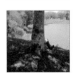

37. Sitting at Lake Apanás, Jinotega, 2010

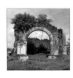

39. Iglesia de San Sebastián, León, 2010

A church destroyed during Somoza's military bombing of León during the 1979 Sandinista revolution.

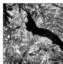

41. Tree Branch at Prison 21, León, 2010

Prisoners were hung upside down from this branch and drowned in a well below. The Somoza-run prison named "21" was noted as a place of horrific torture. Among other heinous acts, guards were known to collect ears and castrate prisoners, as well as having them swallow sharp metal objects tied to a string, then quickly pulling them back out, ripping the esophagus upon extraction.

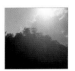

42. Untitled, 2010

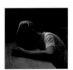

43. Omar #006, Jinotega, 2010

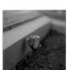

45. The Grave of Benjamin Linder, Matagalpa, 2010

Benjamin Linder was an American volunteer who was building a small hydro-electric dam in rural Nicaragua when he was killed by Contra rebels in 1987.

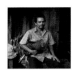

46. Adilio, Jinotega, 2010 (FSLN)

"I was drafted in anticipation of an American invasion."

Adilio holds his prize fighting chicken just before heading off to the fights.

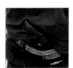

47. Regulated, Jinotega, 2010

Pedro's pistol, stuffed in his pants for protection while he walks around Lake Apanás.

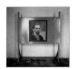

49. Carlos Fonseca, Matagalpa, 2010

A painting of Carlos Fonseca, hero and principal founder of the Sandinista National Liberation Front (FSLN). Fonseca was killed in battle three years before the overthrow of Somoza's government.

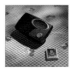

51. Remigio's Silver Cross Radio, Jinotega, 2010

During isolated and uncertain times, Remigio's family would huddle around the small transistor radio to gather information on how things were unfolding and where attacks were taking place.

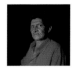

53. Pedro, La Fundadora, 2009 (FSLN)

"The Contras came up from behind us. Right when I got up they shot me. After that I just kept running and running. I saw a big tree and I hid behind it. I could hear them in the distance. When they climbed over the tree I slid as far under it as I could. They stopped for a moment to catch their breath. I could hear them talking about how many 'dogs' they killed. They called us 'dogs.' Laying there I told myself, 'I'm going to die this way.'"

There was a long twisted knot on his arm where the bullet had entered and exited. He vividly described the slippery mud, the incessant rain, and the misery of crawling through the jungle trying to find help. Mid-sentence he paused and stared at me, as if looking for some sort of confirmation that I could fathom the fear of being so close to death.

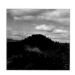

54. Cerro de los Números, Jinotega, 2010

A mountain, covered with foxholes, overlooking La Fundadora, the former plantation of Anastasio Somoza Debalye.

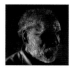

55. Remigio, La Fundadora, 2009

His house was just up near the new coffee processing facility left inoperable due to the theft and sale of the most vital and expensive parts.

Remigio's voice was a raspy whisper from the tracheotomy, his sentences broken by muffled gasps of air through the hole in his neck. He had been at La Fundadora since the times of Somoza. He talked of the free bottles of milk he used to receive in the morning, how Somoza would arrive in his beautiful bullet-proof car, and how everything changed when the plantation was seized.

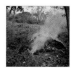

57. Burning Trash, Wiwilí, 2010

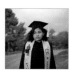

59. Josefina on Her Graduation Day, Jinotega, 2009

60. Foxhole #024 on Cerro de los Números, Jinotega, 2010

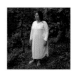

61. Nelita, Jinotega, 2010

Nelita was working at a small market when her village was attacked by the Contras. She heard a loud explosion before the gunfire started.

"After the fighting they dragged me into the woods....."

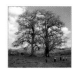

63. Apanás, Jinotega, 2010

Two separate trees with roots intertwined.

ACKNOWLEDGEMENTS

This book is the result of the support and collaboration of many individuals and organizations.

Thank you so much to Austin Turner, Jade Gagnon, Mark Mahaney, Jason Fulford, David Black, Alex Berg, Veronica Gomez, Patrick Aguilar, David Bornfriend, Will Mosgrove, McNair Evans, Eric William Carrol, Lucas Foglia, Paccarik Orue, Christopher Dawson, Alejandro Cartagena, Ursula Damm, Garnel Boyd, Carlos Arietta, Thom Sempere & Photoalliance, CENTER, PDN, Photolucida, Jen Bekman and staff, ONWARD, Rayko Photo Center, and all those I have failed to mention.

The generous people of Jinotega, Matagalpa, and Nuevo Segovia, who shared so much and asked for so little in return. I am eternally grateful.

This book would not have been possible without the unwavering support and commitment of Taj Forer and Michael Itkoff.

And of course my dear Teresa, thank you for your love and patience.